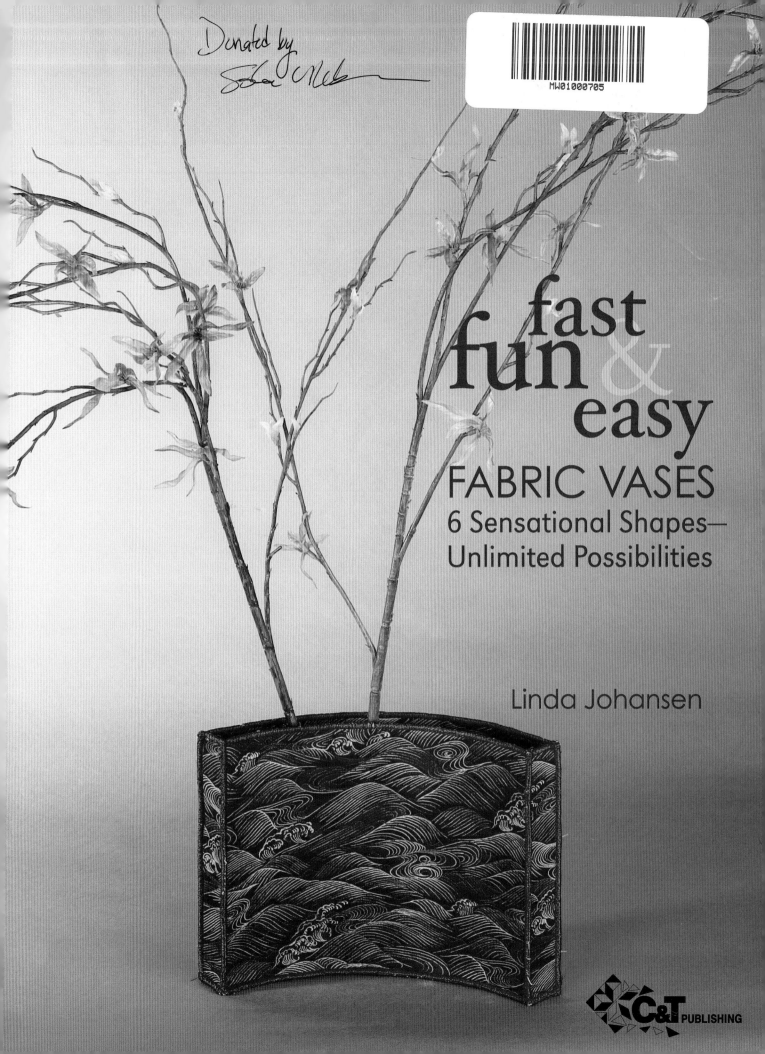

Donated by
[signature]

fast fun & easy

FABRIC VASES

6 Sensational Shapes— Unlimited Possibilities

Linda Johansen

C&T PUBLISHING

Text © 2005 Linda Johansen

Artwork © 2005 C&T Publishing, Inc.

Publisher: Amy Marson

Editorial Director: Gailen Runge

Acquisitions Editor: Jan Grigsby

Editor: Liz Aneloski

Technical Editors: Carolyn Aune, Robin Gronning

Copyeditor/Proofreader: Wordfirm Inc.

Cover Designer: Kristy Zacharias

Book Design: Kristy Zacharias

Page Layout: Kirstie L. McCormick

Illustrator: Kerry Graham

Production Assistant: Kerry Graham

Photography: Diane Pedersen and Luke Mulks, unless otherwise noted

Published by C&T Publishing, Inc., P.O. Box 1456, Lafayette, CA 94549

All rights reserved. No part of this work covered by the copyright hereon may be used in any form or reproduced by any means—graphic, electronic, or mechanical, including photocopying, recording, taping, or information storage and retrieval systems—without written permission of the publisher. The copyrights on individual artworks are retained by the artists as noted in *Fast, Fun & Easy Fabric Vases*.

Attention Copy Shops: Please note the following exception—Publisher and author give permission to photocopy pages 16, 28, 34, 40 and 45–46 for personal use only.

Attention Teachers: C&T Publishing, Inc., encourages you to use this book as a text for teaching. Contact us at 800-284-1114 or www.ctpub.com for more information about the C&T Teachers Program.

We take great care to ensure that the information included in our books is accurate and presented in good faith, but no warranty is provided nor results guaranteed. Having no control over the choices of materials or procedures used, neither the author nor C&T Publishing, Inc., shall have any liability to any person or entity with respect to any loss or damage caused directly or indirectly by the information contained in this book. For your convenience, we post an up-to-date listing of corrections on our website (www.ctpub.com). If a correction is not already noted, please contact our customer service department at ctinfo@ctpub.com or at P.O. Box 1456, Lafayette, CA 94549.

Trademark (™) and registered trademark (®) names are used throughout this book. Rather than use the symbols with every occurrence of a trademark or registered trademark name, we are using the names only in the editorial fashion and to the benefit of the owner, with no intention of infringement.

Library of Congress Cataloging-in-Publication Data
Johansen, Linda
 Fast, fun & easy fabric vases : 6 sensational shapes-unlimited possibilities / Linda Johansen.
 p. cm.
 ISBN 1-57120-317-6 (paper trade : alk. paper)
 1. Machine sewing. 2. Textile crafts. 3. Vases. I. Title: Fast, fun, and easy fabric vases. II. Title.
 TT713.J62 2005
 746–dc22 2005007751

Printed in China 10 9 8 7 6 5 4 3 2 1

Acknowledgments

My life partner—Jay Thatcher—on our new journey together without kids

My kids—Jay and Janelle Johansen and Evan Thatcher—without you I wouldn't be who I am

An honorary kid and friend—Merka Martin—who knows just when to call and lift me up

The girls—Shady—at 15 going on 16, she's made it through numerous kids and four books and Mocha—the stitches that keep a smile on my face and my floor clean

The gals—Alex Vincent, Sidnee Snell, Kim Campbell, and Libby Ankarberg plus, Marc Kemper, and Wendy Yoder Holub—the angels that keep me sane; read more about them at the end of this book.

The store owners and staff that believed in me before I did—Jessica Yorgey and Geary Cuniff of Quiltwork Patches in Corvallis, Barb Schriener of BJ's Quilt Basket in Bend, and Laura Wallace Dickson and Jan Raith at A Common Thread in Lake Oswego

The great folks at C&T—too many to list, and they're all wonderful

All of you who have enjoyed my books and sent me photos and wonderful notes—knowing my books have brought you joy means more than you can imagine

Thank you, all!

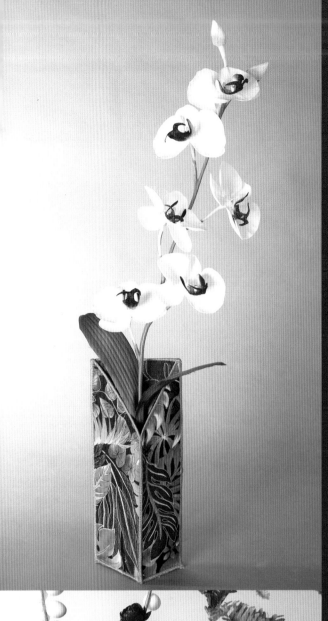

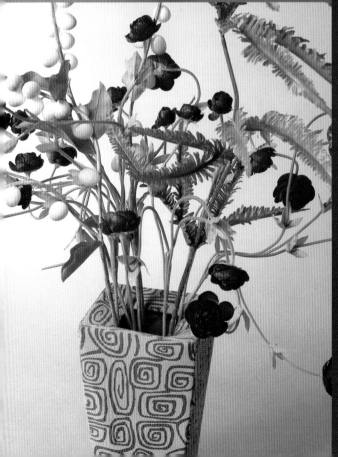

Contents

This book belongs to the
YVPM Quilt Guild
Library

Introduction

I strongly believe that part of our purpose here on earth is to create beauty. When I can combine that beauty with function, the results are deeply satisfying for me. With *Fast, Fun & Easy Fabric Bowls; Fast, Fun & Easy Fabric Boxes; Fast, Fun & Easy Irresist-A-Bowls;* and now *Fast, Fun & Easy Fabric Vases,* you too can bring that beauty into your home and share it with others.

People often ask me if I just sit around thinking up this stuff. I wish I had time to do that! My ideas tend to flow from a combination of my curiosity and my desire to know how to make things for myself. (Chocolate-smelling soaps was one of my better ideas—clean, calorie-free indulgence!)

The idea for making vases came while looking at a small ginger jar I keep on my quilting counter. I never have figured out what to put in it, but it's beautiful, so I keep it. Then I noticed another of my flower vases that has a similar shape with flatter sides. That was enough to start me going on what if . . .

I love the beauty of flowers, and I bring them into the house regularly, so I have a good collection of vases. As the idea of a book developed, I started looking at my vases to see which would lend themselves to fabric and function.

Some of the vases in this book come from playing with and manipulating the fabric bowls and boxes from my other books. In some projects, this will be more obvious than in others—for example, the large triangle vase came from a work session when someone tried a bowl that didn't work as a bowl, but it made a fun vase. The small triangle vase came from playing with a pieced bowl.

With this book, I also wanted to introduce some new construction techniques and ideas. I hope they will open up many new worlds of play for you. Take your time with embellishing, too. It is relaxing and can change how people view the vase.

One of the first questions many of you will have is, "How can I use the vases?" Obviously, you can't put water in them, but you can put a small shot glass or recycled glass jar with a floral "frog" inside to hold real flowers from your garden. You can also use silk flowers with some stones or marbles in the bottom, or try some feathers and grass stalks, or better yet, make some fabric flowers of your own. You can even make the base with a hole in it and put it over a glass or plastic container.

Remember, the purpose is to create beauty and to have fun doing it!

Happy Creating!

all the basics

Use the information that follows to help you choose fabrics and materials, tools, techniques, and vase shapes. Read through it, then refer back here whenever you need some extra guidance.

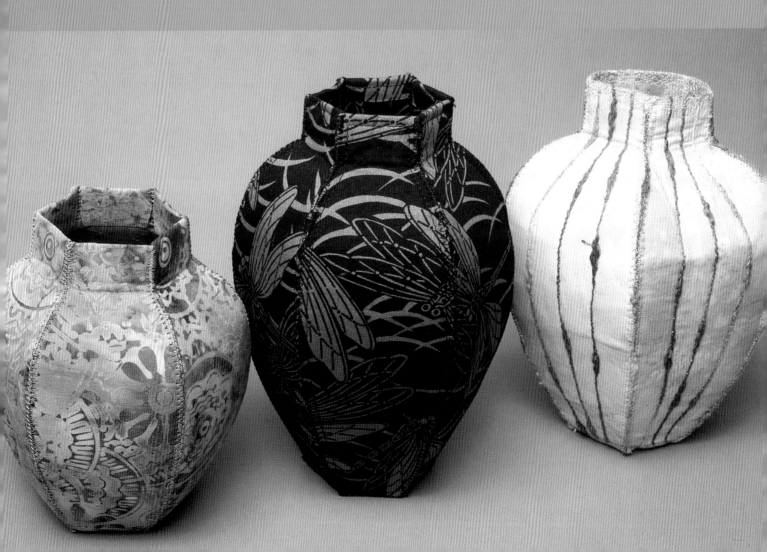

Basic Supplies

The rotary cutting, marking, sewing, and pressing equipment you need is probably already in your sewing room—although maybe not the balloon. For cutting, you will want a rotary cutter, mat, and scissors. For sewing, you'll need a machine, sewing machine needles, thread, and presser feet. For pressing, you'll need an iron with a steam feature, a firm surface, and a sturdy balloon!

fabrics

Good-quality, 100% cotton quilting fabrics are the easiest to work with and give consistently good results. However, don't let this stop you from trying silk, rayon, and other great fun fabrics. Be sure to check the temperature tolerance of the fabric before you fuse it.

stabilizers/stiff interfacing

For all the vases in this book, I have chosen to use fast2fuse or Timtex, because they steam into shape so well.

Fast2fuse™ Double-Sided Fusible Stiff Interfacing (available in regular and heavyweight) is a stiff interfacing with the fusible already on both sides. For most of the vases, this interfacing really simplifies the preparation. Take the time to fuse it well, and you'll love it. It works best if your fabric has been prewashed. The vases with straight sides work better with the heavyweight, and the vases with curved sides work better with regular weight.

Timtex is another, slightly stiffer, interfacing. You must use a fusible web to adhere the fabric to the Timtex for the projects. Simply iron fusible web to your fabric before fusing it to the Timtex, then follow the project directions.

Although canvas is not specified for any of the projects, it can be used in any of them. I recommend two layers of 10-ounce, 100% cotton canvas if you want to try it.

All of these stabilizers can be quilted if you want to embellish your vase.

fusible web

Wonder-Under is the fusible web that I use and recommend. It gives a good bond and won't gum up your needle.

thread

For your first vase or two, stick with a good-quality cotton or polyester thread. I use Mettler cotton thread and Isacord polyester thread. The polyester looks shiny like rayon, but without the breakage. Once you have made a couple of vases, play with some decorative threads.

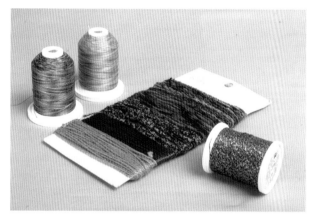

Try decorative threads.

cording

Most of the projects call for cording on at least some of the edges. I find that the cording adds strength and allows for a smoother, rounder finished edge. Having discovered that Speed-Cro-Sheen, size 3 (or other similar size 3 crochet thread), comes in many colors, I now use it frequently without worrying about covering the cording completely. You can also use polyester cording or household string—anything that is about the same thickness as your sandwich. Craft and fabric stores carry some

beautiful decorative cordings and yarns that can negate the need for satin stitching. The best I've found is ⅛˝ rattail cording (see Resources, page 48).

Embellish with decorative cording or yarn.

weights

Most of the vases will be much more stable with some sort of weight in the bottom. There are many things you can use for this—popcorn kernels, fishing weights, pie weights, nuts and bolts, small stones, floral marbles, curtain weights, or floral frogs are just a few.

Many different kinds of weights

sewing machine

Your sewing machine should be able to sew a good satin stitch, which is simply a very close (short stitch length) zigzag stitch. If you want to add surface design, you will also want to be able to drop the feed dogs and use a darning foot.

A satin stitch is just a shortened zigzag stitch.

needles

The machine needle you use really can make a difference. I use top-stitch needles for almost all my machine sewing because they have a larger hole for threading, a deeper slot up the back to protect the thread when it goes through the fabric, and a sharp point for getting through woven fabrics. Usually a size 80/12 top-stitch needle works great. If you use heavier fabric or want a stronger needle for when you need to scrunch the project and move it under the needle, try a 90/14 top stitch needle. Occasionally, I use a fabric for which I want to minimize the needle holes; for this, I use a 70/10 sharp needle and a slower speed with the satin stitching.

sewing machine feet

An open-toe embroidery foot with a slot, or "tunnel," on the bottom allows you to see your stitches. It also allows room for the satin stitching to slide underneath easily. A darning foot allows you to do free-motion quilting or embellishing. The right sewing machine feet make the job much easier.

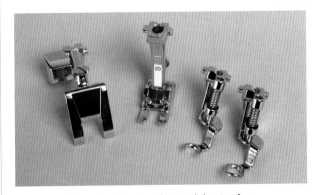

Open-toed embroidery and darning feet

All the Basics 7

scissors

I keep three pairs of scissors handy. A small pair of scissors works well for clipping inside corners and snipping threads. A good sharp pair of cutting shears is best for cutting out project pieces. And nothing beats double-curved, duck-billed embroidery scissors for the final cleanup along the edges of the pieces. Good scissors are a lifetime investment, so buy the best you can afford, not the cheapest you can find.

rotary rulers

I like to use a rotary ruler that best fits the job and the space. Build your supply slowly and buy rotary rulers as you need them. The ones I consider essential are the 6″ × 12″, 8″ bias square, 12½″ × 12½″, 6½″ × 24″, 1″ × 12½″, and 8″ Clearview Triangle rotary ruler. This last one is a 60° triangular ruler that does not have the points nipped off, and it works best for the triangular projects in this book.

rotary cutter

After having a student miss a class because she was in the hospital getting stitches in her foot from a dropped rotary cutter, I did some experimenting by dropping different rotary cutters. Almost all of the cutters popped open when they hit the cutting mat—even when supposedly locked. The only one that did not was the Olfa Deluxe ergonomic locking cutter. As a result, I *strongly* recommend this rotary cutter. It has a small red button that you push through from one side to the other to lock. It may take you a few cuts to get used to the shape, but if you have kids, pets, or feet, the safety involved is worth it. Put safety first. Use a rotary cutter that easily locks securely.

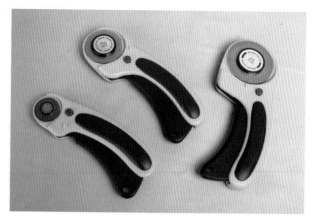

Olfa Deluxe locking cutters

rotary mat

Since you won't need marking or cutting lines on your mat, use the unlined side. I like the gray side of my mat—everything but gray fabric shows up really well on it, and I don't often sew with gray fabric.

iron

Buy the cheapest iron available that lets you turn off the steam at any temperature and that will turn itself off after 15 minutes or so. You will need the steam for shaping the projects. And I love not having to remember to turn the iron off every time I get distracted by something else. Plus, I am prone to dropping irons, and it's a lot cheaper to replace an inexpensive one (we won't talk about the holes in the floor).

ironing board

A larger board for ironing can make your life a lot simpler by decreasing the amount of time you spend moving the fabric. You can easily modify your ironing board with a piece of ¼″ plywood. Cut it 18″–20″ wide by about 2″ longer than the length of your ironing board. Bolt the plywood to the board at both ends. (I used four ½″ bolts with low rounded heads.) Cut two pieces of cotton batting about 2″ larger than the board and layer them on the board. Then cover with two layers of white

fabric that is about 6″ wider and 6″ longer than the board. Cut about five 16″ lengths and one 47″ length of ½″–¾″-wide sturdy elastic. Fold under 1″ at each end, and put a pin in the folded edge. Evenly space the elastic, and pin it to the edge of the fabric to stretch the fabric snugly over the board. Make sure the pins stay under the edge of the board. When the fabric gets dirty or gets too much fusible web on it, simply refold and repin for a clean side.

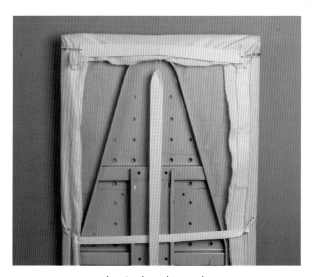

Ironing board extender

pressing sheets

Both June Tailor and Clotilde make nice, large, translucent Teflon sheets for putting *under* your work on the ironing board to keep it clean. The brown Teflon sheets that can also be used in the oven tend to get very hot.

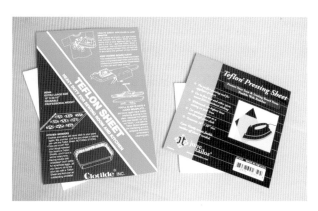

Pressing sheets

template material

Most quilt and craft stores carry a transparent template plastic that is easy to mark and cut. It also works well for fussy cutting your pieces. You can use paper, but it tends to change shape as you use it.

balloons

You can use balloons to round out the shape of the vases while you steam iron them to shape. Have several sizes of sturdy round balloons on hand. (You can reuse these balloons.)

Basic Techniques

fusing/pressing

Lightly iron the fabric onto the first side of the fusible stiff interfacing, and then trim to the edge of the interfacing so that you can see where to draw your pieces. Firmly iron the fabric to the second side. Flip it back to the first side, and press firmly. Be sure that all corners are fused well.

If you use fusible web, follow manufacturer's instructions to fuse the web to the back of the fabric just enough to hold. If the fusible layer comes off when you pull the paper off, iron it a bit more. If you do too much ironing, however, the paper can get brittle and become very difficult to peel off.

marking

For marking the pattern pieces on your sandwich, you can use anything that will not bleed. I tend to use whatever is handy, which is usually a pencil or ballpoint pen. Cut the template to the size given.

stitching

Getting a good satin stitch is sometimes the most difficult part of the project. Practice helps a lot, and trying different settings on your machine can make a big difference. Remember that your machine has a thick layer on one side of the feed dogs and nothing on the other side. It may need gentle help now and again.

Some things to try:

☐ Lower your upper thread tension to about 2.

☐ Set the stitch length to .2 or .3, depending on your machine.

☐ Let the machine do the work. Don't try to push or pull the project. It *will* move slowly with a good satin stitch.

☐ Use a presser foot that has space on the bottom to allow room for the satin stitch. I recommend an open-toe embroidery foot.

☐ Lower the presser foot tension a bit if your machine allows for it.

☐ Try a different stitch. Some machines have a zigzag-like stitch where one stitch goes straight across and one comes back at an angle. Other machines have a "double" zigzag stitch.

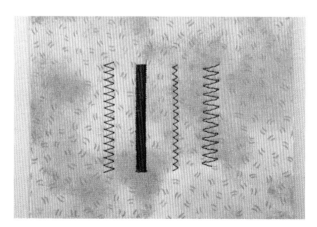

Zigzag, satin, narrow zigzag, and mending stitches

applying cording

Use a cording that is slightly thinner or the same thickness as your sandwich. I like cotton cording, because it takes a colored pen better when the stitching doesn't quite cover and I have to fill in with a pen! Size 3 Speed-Cro-Sheen thread (or a similar size 3 crochet thread) is available at many craft stores and comes in colors if black or white don't work for you. You may need to ask the store to carry it. If you use a softer cotton thread, try twisting it tighter to get a smoother finish.

Sew the cording on with a zigzag stitch, then do the satin stitching as a *separate step*. You will not save time by trying to do it all at once! And, yes, that's the voice of experience.

easy!

If you want to avoid satin stitching, use rattail cording or another decorative cording that is slightly wider than the sandwich thickness.

Set your machine for a 4.0-width, 1.5-length zigzag stitch. Lay the cording next to the sandwich edge, with enough behind the presser foot so that you can hold onto it. Stitch a few stitches in place to hold the cording.

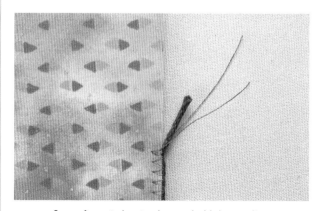

Sew a few stitches in place to hold the cording.

Zigzag the cording around the piece. Keep the right side of the stitch just over the cording. As you sew up to the inside corners, pull the cording under the sandwich so that you can stitch clear into the corner (or curve). Stop with the needle down, just outside the cording at the corner. Pull the cording out from under the sandwich, and turn the sandwich so that the cording is again along the edge. Continue zigzag stitching.

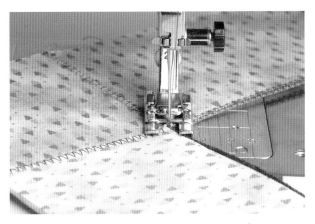

Stop with the needle down when turning an inside corner.

Before you get too close to the end to easily reach the beginning tail of the cording, clip it. Trim it as close to the stitching as possible. As you finish zigzagging the cording, sew right up to where you started, and sew a few stitches in place. Trim the cording close to the stitching so that the two ends butt up to each other.

Clip the cording so that the two ends butt up to each other.

steaming

The vases will steam to shape quite nicely. Just blow up a sturdy balloon inside the vase, and hold the balloon closed while you iron with steam. For the sides, leave the balloon in while it cools. Steam the base after you have done the sides, and hold it on a cool counter or other surface so that it will cool flat.

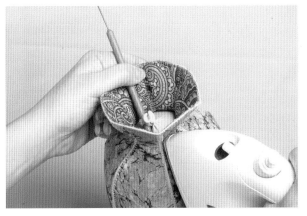

Steam the rounded vases with a balloon inside.

fast!

Change the iron to a dry setting after steaming, and iron the vase dry.

small triangle
vase

Put a small votive glass in your vase, and fill it with short-stemmed flowers for a quick, unique gift. Try Asian fabric, whimsical fabric, or whatever suits your fancy.

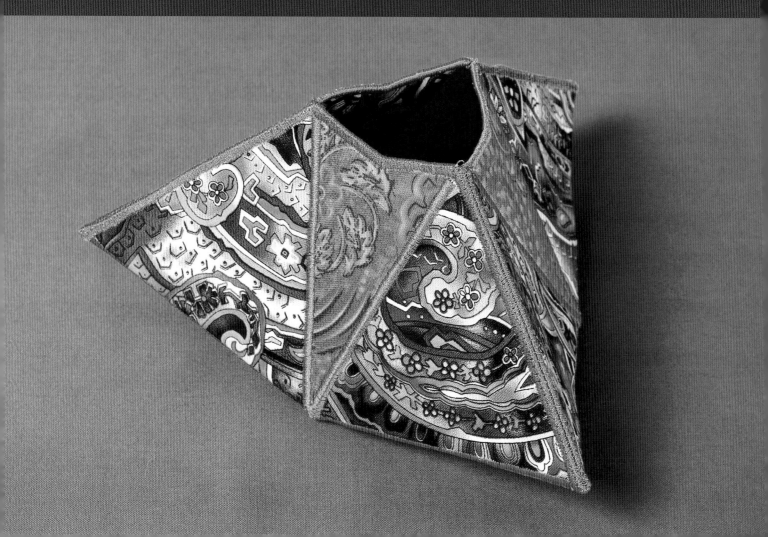

What You'll Need

- ☐ 2 fat quarters coordinating fabrics
- ☐ 10″ × 12½″ stiff interfacing (If using directional fabric, you will need larger pieces of interfacing, approximately 12″ × 18″.)
- ☐ 20″ × 12½″ fusible web, if not using fast2fuse
- ☐ 1¼ yard cording
- ☐ Thread to match or contrast with fabrics
- ☐ Template plastic (optional)
- ☐ Clearview Triangle ruler (optional)
- ☐ Side triangle and 3½″ equilateral triangle patterns (page 16)
- ☐ Basic supplies (pages 6–9)

How-Tos

fusing

1. Cut 1 piece of stiff interfacing and 2 pieces of fabric each to about 10″ × 12½″. (If using directional fabric, cut your interfacing and fabic to about 12″ × 18″.)

2. If you are not using fast2fuse, cut 2 pieces of fusible web the same size as the stiff interfacing.

Cut fabrics and stiff interfacing the same size.

3. Fuse fabric A to one side of the stiff interfacing.

4. Fuse fabric B to the other side of the stiff interfacing. Press firmly with a hot dry iron (cotton setting) to make sure both sides are fused well.

fun!

Use up your scraps! Fussy cut all the triangles first, and put a light fabric on one side and a dark fabric on the other. Then mix and match!

cutting

1. Cut 2 strips 3½″ × 12½″ of the sandwich (3½″ × 18″ if using directional fabric).

fun!

Fuse some extra fabric to fussy cut the triangles. Cut all the triangles, or just the small side ones.

2. Using the Clearview Triangle ruler, the 3½″ triangle pattern (page 16), or the 60° line on your rotary ruler, cut 5 equilateral triangles 3½″ high from each strip.

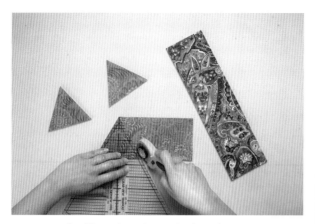

Cut 10 equilateral triangles from 2 strips.

3. Trace the narrow side triangle pattern piece (page 16). Cut 3 from the remaining piece of fused sandwich.

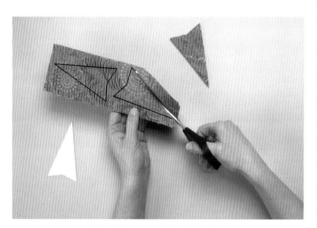

Cut 3 narrow side triangles.

stitching the sides and base

1. Zigzag 3 equilateral triangles, B side up, to the sides of an equilateral triangle, A side up. These will form the base.

Zigzag 3 triangles to the base triangle.

2. Zigzag 2 equilateral triangles, A side up, to each of the sides sewn on in Step 1.

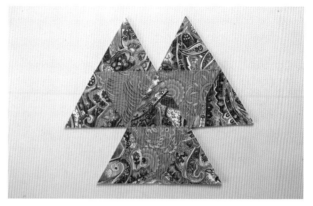

Zigzag 2 side triangles onto each side.

3. Zigzag the narrow side triangles, B side up, to one side of 3 of the equilateral triangles.

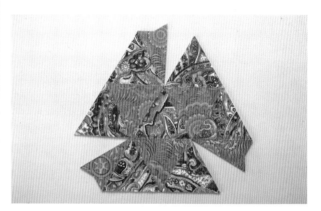

Sew the narrow triangle to one side of 3 equilateral triangles.

4. While the piece is flat, satin stitch all the *joints* (only the joints, not the sides—you will pull those together in the next step).

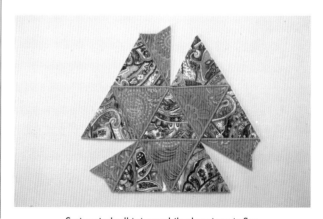

Satin stitch all joints while the piece is flat.

5. Slowly pull the unstitched sides of the narrow and equilateral triangles together just in front of the needle and satin stitch them. You can zigzag the seam first if that is easier for you.

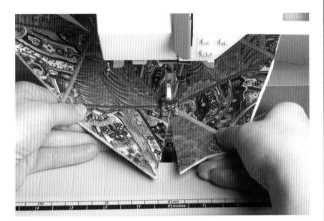

Slowly pull the sides together as you sew up the dart.

adding the cording

1. Zigzag the cording around the edge of the whole piece. (For complete directions on adding the cording, see page 10–11.) Lay the cording next to the edge of the piece under the presser foot.

2. Set your machine for a 3.5-width, 1.5-length zigzag stitch. Stitch a few stitches in place to hold the cording, then continue around the piece. Make sure your needle goes over the cording on the right side.

3. Before you get back to where you started, clip the cording very close to the first stitching.

4. Zigzag right up to where you started, stitch a few stitches in place at the end, and clip the cording close to the stitching so that it butts up to the starting end.

5. Satin stitch around the edge, over the cording, with a 4.0 or slightly wider stitch.

shaping the vase

1. Fold the vase gently in half, with 2 equilateral triangles flat together to make "points." The narrow triangles will be in the center of the "sides."

2. With matching thread, use a short, narrow zigzag stitch (1.5 width and 1.5 length) to stitch the corners together. The right side of the zigzag should go over the edge. You want to just barely catch the edges of the pieces to hold them. If you use a wider zigzag, the corner will stick out more, which is another option!

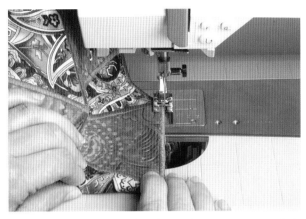

Fold the vase flat, and sew the edges with a narrow zigzag stitch.

easy!

Begin sewing at the top edge of the vase, and sew to the corner so your top edges will always match.

3. Backstitch with the zigzag stitch at both ends of the seam. If needed, use thread glue to hold the ends.

fun!

Use some embroidery thread and a decorative stitch or two to sew the edges by hand.

finishing

Steam to shape, if needed, and trim any wayward threads.

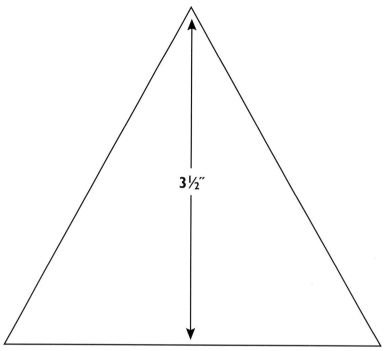

3½″ Equilateral Triangle for Small Triangle Vase

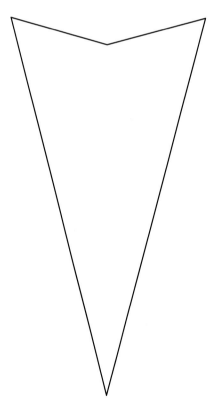

**Narrow Side Triangle
for Small Triangle Vase**

Make it yours!
This vase is so q u i c k to make,
you can spend your time
e m b e l l i s h i n g it.

Variations

Once you've made one vase, forget the instructions and make another any way you like. Play with the shape, the materials, and the embellishments.

A. Cut and satin stitch some holes in the pieces before sewing for more space to put flowers. See-through vase, by Alex Vincent

B. Change the sizes of the side triangles, and lace up the sides for a very flowing look. Laced vase, by Sidnee Snell

C. High-contrast, delightful doggy print fabric with angled edges adds some fun. Dog-print vase, by Marc Kemper

D. Make the whole vase out of larger triangles for a bigger impression. Music vase, by Linda Johansen

E. Change the shapes of the base and the side pieces for a unique look. Tall vase, by Sidnee Snell

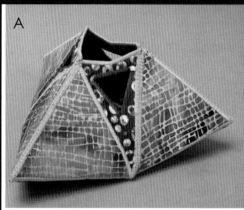

A

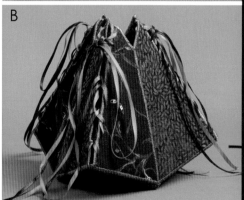

B

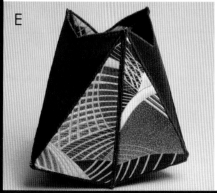

E

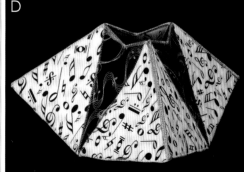

D

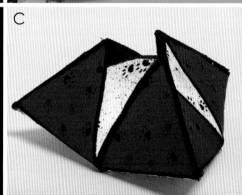

C

rectangle vase

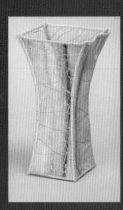

The simple clean lines of this classy vase, with a bit of embellishment, make it just the thing for holding spring flowers.

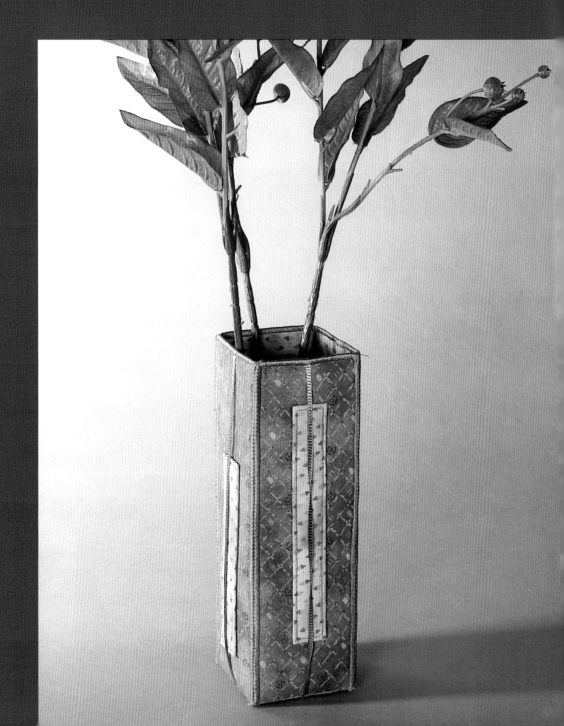

What You'll Need

- 2 fat quarters coordinating fabrics
- 12½" × 11" stiff interfacing
- 8" × 8" (or scraps) fusible web (¾ yard if not using fast2fuse)
- 1 yard decorative ribbon or yarn
- Thread to match or contrast with fabrics
- 2½ yards cording
- Basic supplies (pages 6–9)

How-Tos

fusing

1. Cut the stiff interfacing and a piece of each fabric to 12½" × 12½". If you are not using fast2fuse, you will also need to cut 2 pieces of fusible web 12½" × 12½".

2. Lightly fuse one layer of fabric to the stiff interfacing.

3. Turn the sandwich over, and fuse the second piece of fabric to the other side.

4. Press firmly, and be sure all edges are fused well on both sides.

cutting the vase

1. Trim the edges of the square sandwich to square it up. Trim as little as possible to get clean edges and square corners.

2. Cut an 8″-wide strip from the square, then cut this strip into 4 pieces 8″ × 2½″. These will be the sides of your vase.

Cut the 8″-wide strip into 4 pieces.

cutting the embellishment pieces

1. From the remaining sandwich pieces, cut 1 base square 2½" × 2½" and cut 3 strips ¾" wide along the longest side. Cut these strips into pieces ¾" × 2¾", ¾" × 3¾", ¾" × 4½", and ¾" × 5½".

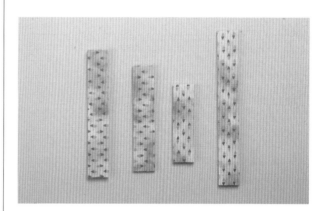

Cut 4 embellishment pieces.

fun!

The embellishment pieces can be any size or shape you like. It's just another excuse to play!

2. From the same fabric that you used for the inside of the vase, cut 1 piece 7″ × 8″.

3. Cut a similar piece of fusible web, and iron it to the back of the fabric.

preparing the embellishment pieces

1. Cut the fusible-backed fabric into 4 strips 2″ × 7″.

2. Center one small embellishment piece on a strip of fused fabric. You can fuse to either side of the piece, because the back won't show.

3. Hold the piece in position as you turn it over and fuse the fabric to the piece.

4. Repeat this for each small piece.

5. Trim the edges of each piece so the fabric is ½″ wider on each side and ⅜″ longer on each end.

Trim fused embellishment pieces.

6. Fold the short ends over the sandwich, and fuse the excess fabric to just the sandwich. Tuck the extra fabric on the end down next to the sandwich and press. This allows the longer edge to overlap and still be shorter than the sandwich.

Tuck the sides of the end flap in a bit to get a good corner.

7. Fold the long sides over to the back, and iron them down.

embellishing the sides

fast!

Try some overall stitching embellishing before you cut into the sandwich.

1. Place the sides next to each other on a table. Place an embellishment piece on each side to decide where you want to position the embellishment pieces—these pieces will look better if they are not centered either vertically or horizontally.

Audition fabrics to decide placement of embellishments.

2. Sew the embellishment pieces in place, one at a time, topstitching about 1/16″ inside the edge. Use a needle-down position to turn the corner, and shorten the length of the straight stitch to lock your stitches at the end.

3. Cut four 9″ lengths of your ribbon or yarn.

4. Center a piece of yarn or ribbon over the small embellishment piece, and sew the end with a shortened straight stitch right at the end of the side piece. Be sure this stitching is close enough to the edge so that later satin stitching will cover it.

5. Twist the ribbon a few times (or none at all for one or two sides). Using a shortened straight stitch, tack down the loose end of the ribbon by stitching very close to the edge of the piece.

Tack down the ribbon's loose end.

easy!

For a different look, place the ribbon side to side, top to side, or at an angle.

assembling the vase

1. Place the sides in the order you want them.

2. Sew them to the base with a 4.0-width, 1.5-length zigzag stitch. Keep the embellished side up so that your ribbon doesn't get flattened as you sew.

Zigzag sides to the base, with embellishments facing up.

3. Zigzag cording onto all the edges, using the same stitch setting as in Step 2. (See pages 10–11 for complete instructions on applying the cording.)

4. Satin stitch over the cording with a 4.0-width, .2-length stitch.

5. Satin stitch around the base with the same settings as above.

shaping the vase

1. Fold the vase in half, with 2 adjacent sides together, to sew the sides. Sew the outside edges only.

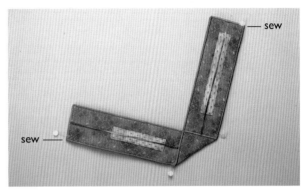

Fold the vase in half.

2. Starting at the top, zigzag down the side with a 1.5-width, 1.5-length stitch. Backstitch at the beginning and end of the seam, and make sure the top edges are even; you can pin them if you want. The right side of the stitch should go just barely to the right of the pieces, and the left side should just catch both pieces.

3. Fold each of the last 2 sides together, and sew one at a time. It's okay to bend the stiff interfacing; you can steam it to shape later. Remember to backstitch at both the top and the bottom.

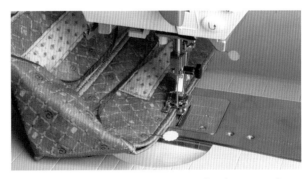

Scrunch the vase to get the last edges under the presser foot.

4. Steam the sides and bottom to shape, being careful not to steam the ribbon flat.

You'll **love** this vase for its clean lines and **elegant possibilities.** Of course, you can always make it **funky or folksy** with embellishments, if you choose.

Variations

Straight sides often went by the wayside with this vase. It was just too much fun to play with all the options.

A. Skinny, concave sides make for a more ethereal feeling. Tall vase, by Kim Campbell

B. You can make cover-ups for "found" vases, like this curved rectangle.
Curved vase, by Kim Campbell

C. Make a broad side with concave curves to get a sturdy vase just right for some beaded embellishment. Beaded vase, by Alex Vincent

D. Make the sides slightly convex, and add different embellishments. This completely changes the style of the vase. This vase was made with paper, by Linda Johansen

E. Concave sides, a smaller shape, and a delicate pink fabric make a sweet vase. Delicate vase, by Alex Vincent

A
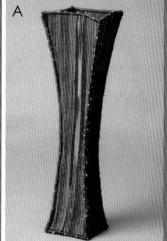

E
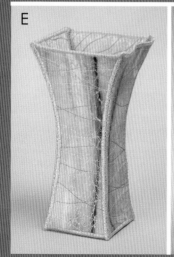

D
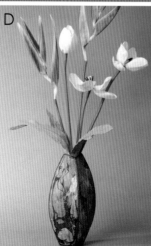

C
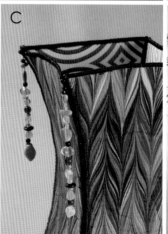

B
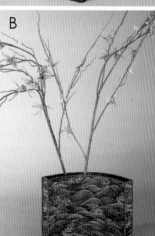

large triangle
vase

Everyone will wonder how on earth you put this one together! It's just right for flashy, high-contrast fabrics and embellishments.

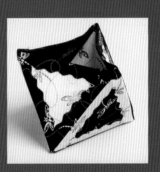

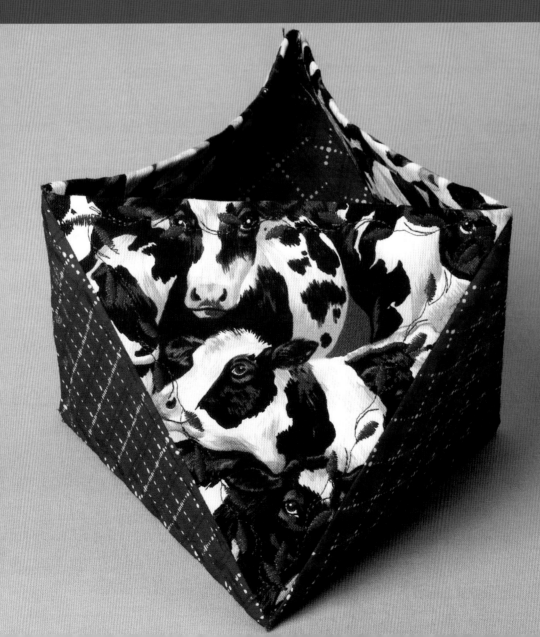

What You'll Need

- [] 2 fat quarters contrasting fabrics (See note with Step 2 below about using directional fabrics.)
- [] 10″ × 15″ stiff interfacing (I recommend heavyweight fast2fuse or Timtex and fusible web for this vase.)
- [] 1⅓ yards fusible web (or ⅞ yard if using fast2fuse)

- [] Thread to match or contrast with fabrics
- [] Template plastic (optional)
- [] Clearview Triangle ruler (optional)
- [] Triangle patterns (page 28)
- [] Basic supplies (pages 6–9)

How-Tos

cutting

You will cover four triangles with one fabric (A) and three triangles with the other fabric (B). Fabric A will show the most on the outer sides.

1. Cut the stiff interfacing into 2 strips 5″ × 15″.

2. From fabric A, cut 1 strip 5″ × 15″ and 1 strip 7″ × 22″. From fabric B, cut 1 strip 5½″ × 12″ and 1 strip 7″ × 18″. Cut 1 strip of fusible web 7″ × 22″ and another 7″ × 18″. If using Timtex, cut additional strips of fusible web 5″ × 15″ and 5″ × 12″. (If using a directional fabric, you will need to cut an additional 7″ × 8¾″ piece of each fabric and fusible.)

fusing

1. Iron the fusible web to the 7″-wide fabric strips. (If using Timtex, also fuse web to the 5″-wide fabric strips.)

2. Fuse the 5″-wide fabric strips to one side of each of the stiff interfacing pieces.

3. Using the Clearview Triangle ruler, the 5″ triangle pattern (page 28), or the 60° angle on your rotary ruler, cut the strips into 7 equilateral triangles 5″ high.

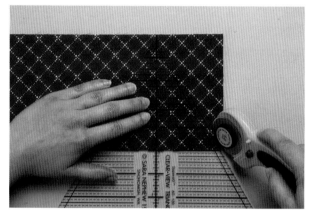

Cut strips into equilateral triangles.

4. Cut the 7″-wide strips of fusible-backed fabric (with the paper on) into 7″-high equilateral triangles— 4 of fabric A and 3 of fabric B. (For directional fabrics, decide which direction you want the triangles to face before cutting.)

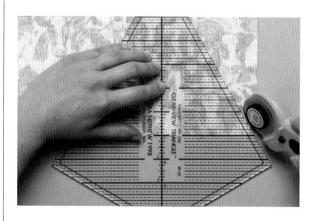

Cut 7″ fabric into equilateral triangles.

5. Fuse a 5″ triangle (stiff interfacing with fabric on one side) to the center of each large fabric triangle, matching fabrics. To do this, center the smaller triangle on the large one, then carefully turn it over and press to fuse. Be sure to use a protective sheet to keep the fabric edges from fusing to your ironing board!

Place the stiff interfacing in the center of the fabric triangle, and turn it over to fuse.

6. Trim the fabric to ½″ from the edge of the stiff interfacing on all 3 sides of each triangle.

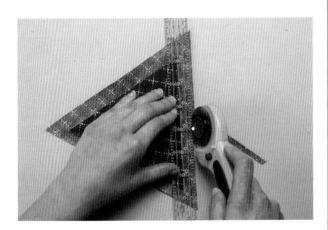

Trim the edges to ½″ wider than the stiff interfacing.

fun!

For the second side, trim the fabric to shape with a wave rotary blade, and "forget" to turn the vase inside out at the end.

stitching the sides

1. Place a fabric A piece back to back with a fabric B piece—large pieces of fabric right sides together, with the stiff interfaced pieces facing out.

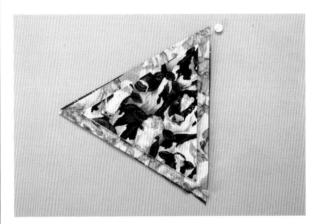

Place an A piece and a B piece back to back, and sew along one edge.

2. Backstitch at the corner of the stiff interfacing, and sew parallel to one side about ½₂″ away from the edges of the interfacing. This is just narrower than the thickness of one layer of your sandwich. End the seam at the corner of the interfacing. Backstitch at the end of the stiff interfacing. This leaves the ends of the fabric free to fold and trim later.

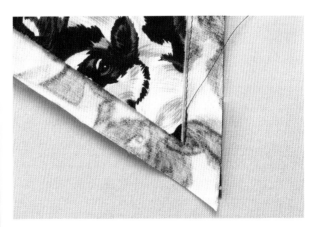

Backstitch at both ends of the seam.

3. Sew 2 more B pieces onto the A base the same way. Do not sew beyond the interfacing into the fabric corners. Fold these corners out of the way if necessary.

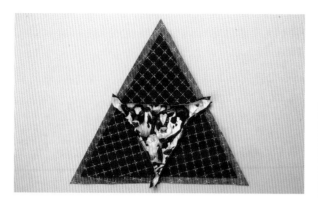

Sew three B pieces to the A base.

4. Sew the remaining A pieces onto one edge of each B piece, the same way you did above. (See photo below for placement.)

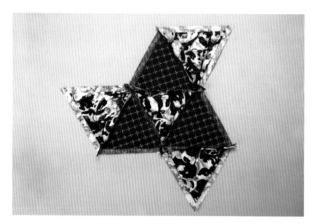

All 7 pieces sewn together

5. Fuse the seam allowance of the sewn edges back onto the stiff interfacing, leaving about 1˝ unfused at the corners. Do not fuse down the fabric corners yet.

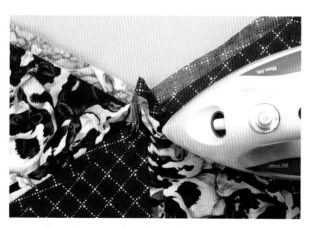

Fuse the sewn edges down, but not the corners.

6. Fuse one seam allowance to the corner, keeping the other seam allowance free. Trim the point of the fused seam allowance. Fold over the remaining seam allowance, fuse, and trim even with the sandwich.

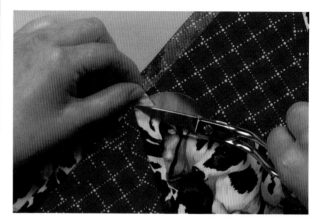

Trim the point after fusing one seam allowance.

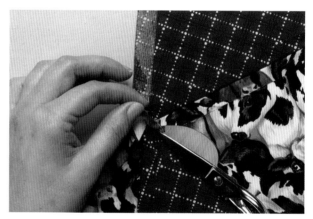

Press the second seam allowance and trim.

fun!

For a fun embellishment, sew a decorative stitch around each edge of every triangle once all pieces are sewn together and still flat.

shaping the vase

1. With the vase inside out, bring 2 adjacent A and B pieces face to face, and sew parallel to the stiff interfacing, the same way you did in Step 2 of Stitching the Sides. Remember to backtack at the beginning and end of the seam. At the corners, fuse and trim the seam as you did in steps 5 and 6 before you sew the next seam.

Shape the vase by bringing two sides together to sew.

2. Keeping the vase inside out, bring the next 2 A and B pieces face to face, and sew them the same way. Because you now have a three-dimensional vase, you will need to do a bit of scrunching and pinning to keep the seam aligned while you sew.

Scrunch the vase to sew the rest of the shaping seams.

3. Sew the third seam the same way, then fuse and trim it.

finishing

1. Trim the side seam parallel to the top edge of the vase.

Trim the fabric parallel to the top edge.

2. Fold over the top edge, and trim off a small triangle.

Trim off a small triangle.

3. Fuse the loose fabric across the corner seams.

4. Repeat this for the other side of the same corner to strengthen the corners.

5. Carefully turn the vase right side out and steam the sides flat.

easy!

Tack the sides' top edges together about 1″ in from the corner if the steaming doesn't hold.

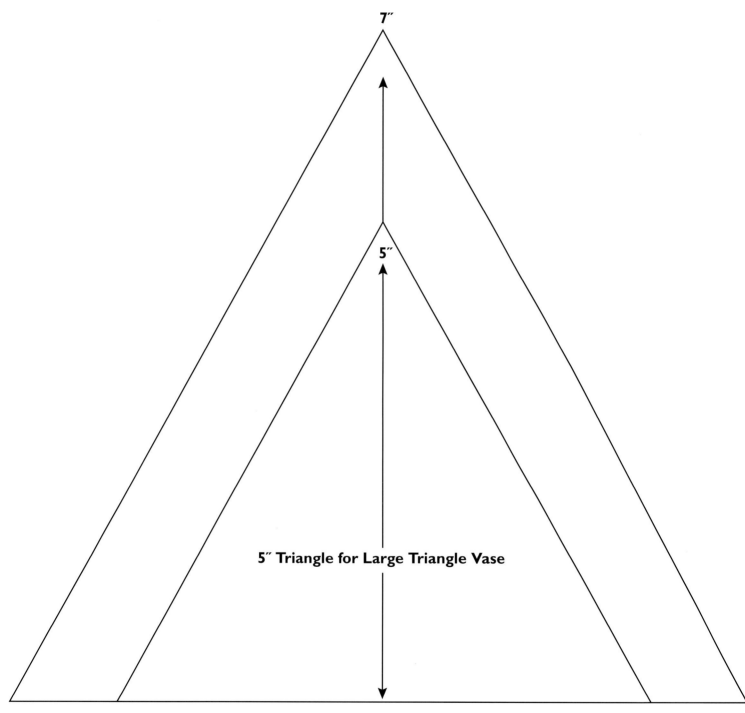

7"

5"

5" Triangle for Large Triangle Vase

7" Triangle for Large Triangle Vase

Add some embellishments
and a short glass jar
for a great vase to hold some
big and floppy flowers.

Variations

With so many edges and shapes to play with, you can't go wrong tri-ing this one.

A. Change the angles on the triangles for a couple of tall thin vases. Tall triangle vases, by Libby Ankarberg

B. Cut the side fabric with a wave blade, and "forget" to turn it right side out to show off the fabric a bit more. Wave vase, by Sidnee Snell

C. Smaller triangles work, too! Dragonfly vase, by Linda Johansen

D. Christmas fabric, decorative satin stitching, small sleigh bells, and ribbon create a wonderful holiday vase. Christmas vase, by Alex Vincent

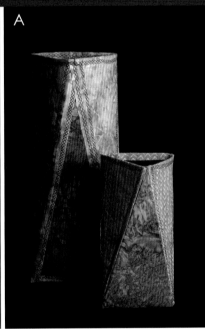

A

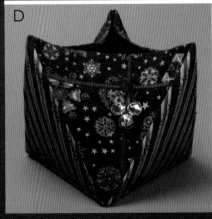

D

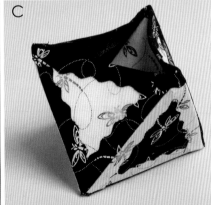

C

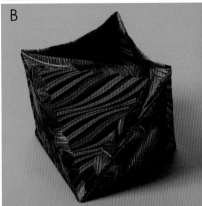

B

ginger jar vase

This sweet little vase is soooo easy you won't believe it! Slip some weights inside, and fill with your favorite feathers instead of flowers.

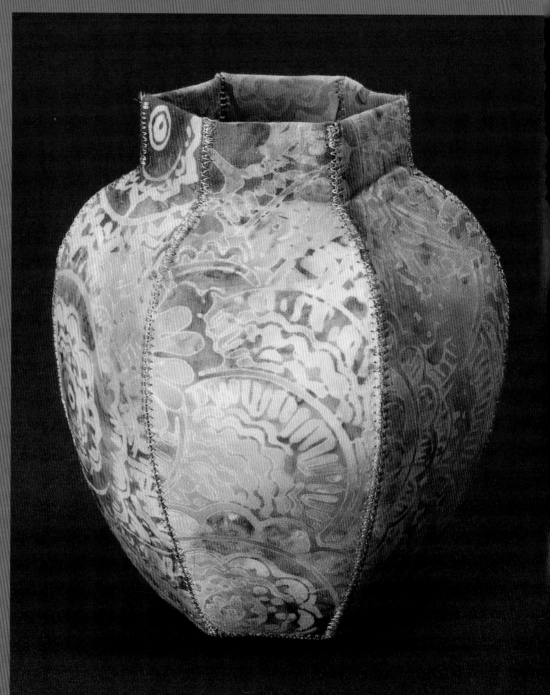

What You'll Need

- ☐ 2 fat quarters (or 2 scraps the same size as the stiff interfacing) coordinating fabrics (If using the same fabric inside and out, use 1 fat quarter for the small vase and ⅓ yard for the large.)

- ☐ 1 piece 5½″ × 15″ and 1 piece 2½″ × 2½″ stiff interfacing for small vase *or* 1 piece 8″ × 16″ and 1 piece 2½″ × 2½″ for large vase (I recommend fast2fuse for this vase for its ease of fusing and flexibility.)

- ☐ ¾ yard fusible web (1⅛ yards if not using fast2fuse)

- ☐ Thread to match your fabrics

- ☐ Template plastic (optional)

- ☐ Sturdy balloon

- ☐ Base and side patterns for small or large ginger jar vase (page 34)

- ☐ Basic supplies (pages 6–9)

How-Tos

fusing

1. Cut a piece of fabric 16″ × 6″ for the small vase or 17″ × 7½″ for the large vase—this fabric will be on the inside of your vase. (If not using fast2fuse, cut 1 piece of fusible web the same size as the fabric.)

2. Fuse the fabric to one side of the stiff interfacing. Press firmly, and test to be sure all corners and edges are fused well. (If not using fast2fuse, apply fusible web to the back of the fabric first.)

3. Cut a piece of fabric 23″ × 7″ for the small vase or 23″ × 10½″ for the large vase—this fabric will be on the outside of your vase. Cut a piece of fusible web the same size as the fabric. Apply fusible web to the back of the fabric piece, and set aside for now.

fun!

Fussy cut the outer fabric for the sides of your ginger jar. It takes a bit more fabric, but what a great look!

cutting

1. Trace side piece and base patterns (page 34) onto template plastic, and cut them out. Trace 6 sides and 1 base onto the stiff interfacing sandwich.

Trace the pattern on the fabric 6 times.

fast!

Cut out 6 patterns from freezer paper, and iron them on the fabric side of your sandwich to cut around. Be gentle when pulling them off!

2. Cut out all the pieces. I like to use a rotary cutter. However, on inside corners, I use small sharp scissors.

easy!

Use a sturdy French curve to rotary cut the sides. That's what I used to draw them!

3. Lay the stiff interfacing pieces on the second piece of fabric, and cut around each, leaving the fabric a generous ½" wider on all sides and ¾" across the top.

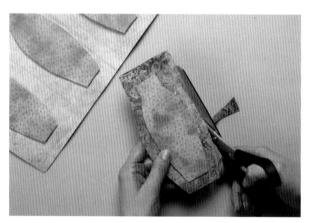

Cut a generous ½" all around, plus ¾" across the top.

4. With the fabric side up, center each sandwich piece on the fabric piece under it, and carefully turn it over and fuse it on.

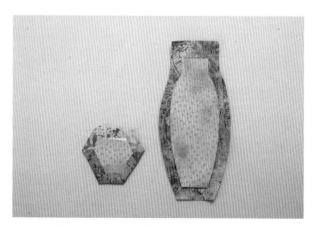

The base and one side ready to begin fusing

5. Clip straight in toward the inside corners at the neck of the vase side.

6. Fold in the sides, and fuse them to the back of each side. Pull them snugly against the edge as you fold them over.

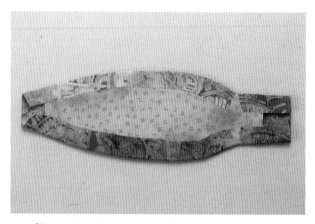

Clip to the inside corners, and fuse the sides over first.

7. Trim a bit off each corner of the fused fabric, and tuck the edge in so that there is more fusible surface to hold the top and bottom as you fold it over and fuse. This also ensures that the folded-over edges are inside the edges of the whole piece.

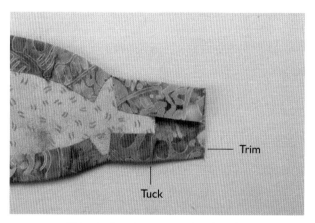

Trim the fused corners and tuck in the edges for a good clean look.

stitching to the base

1. Set your machine for a zigzag stitch (1.5–2.0 width, 1.5 length). Check your stitches and tension on a scrap of stiff interfacing with fabric fused on both sides.

2. Place one side at a time on the base, with the bottom edge even with one side of the base. Inside fabrics will be face to face. I like to sew 2 or 3 stitches in place at the start and end of each piece.

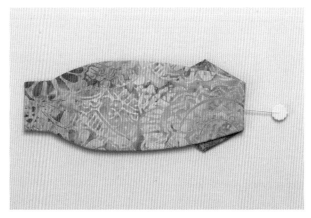

A side piece lined up and ready to sew

3. Continue around the base, zigzagging each side . You will need to open each piece out before you sew on the next one.

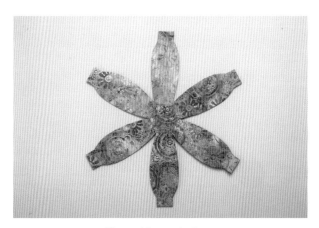

Zigzag sides to the base.

shaping the vase

1. Set your machine for a zigzag stitch (1.5–2.0 width and 1.5 length).

2. Fold 2 adjacent sides together, with the fabrics you want inside the vase facing each other.

3. Pin the top edge of the vase so that it stays even.

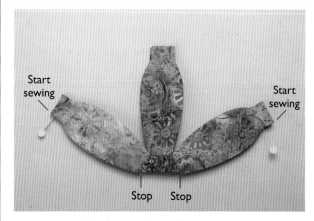

Pin the top edge to keep it even.

4. Hold the sides together while you zigzag the edge. The outside stitch of the zigzag should go over the edge of the two sides, and the inside stitch should just catch the edge of the fabric around the sides.

5. Be sure to do some extra stitches in each inside corner and at the top and bottom edges to strengthen them.

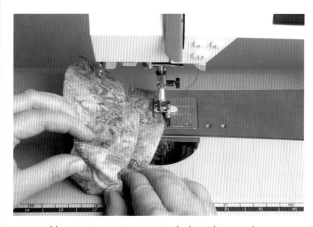

Use a narrow zigzag to stitch the sides together.

finishing

1. Push the sides of the vase out to the shape you like, and steam iron just a bit to help shape it. Use a balloon, or shape it with your fingers as it cools.

2. Steam iron the base, and then set it on something flat while it cools.

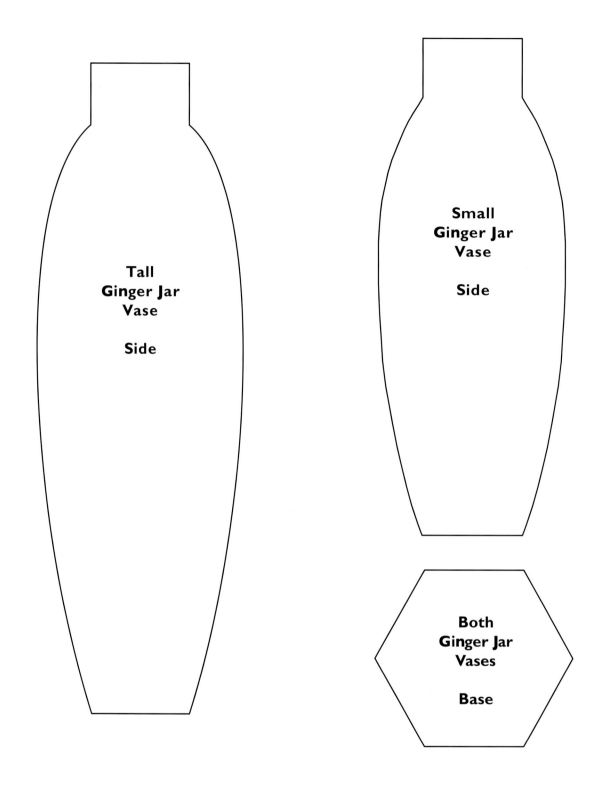

Tall
Ginger Jar
Vase

Side

Small
Ginger Jar
Vase

Side

Both
Ginger Jar
Vases

Base

Pleeeasssse

don't tell anyone receiving this
how easy it was to make!
You'll be the hit of the family, office, or club.

Variations

Once you've made one vase, forget the instructions and make it any way you like. Play with the shape, the materials, and the embellishments.

Add some candy...even candied ginger! Set it beside your sewing machine, and you're fueled for making the next one.

A. **For an inside nature scene, add some berries to a "natural" fabric, put some weights inside the vase, and enjoy.** Berry vase, by Sidnee Snell

B. **Make a fat little jar, and add a lid for an Asian treasure.**
 Ginger jar, by Linda Johansen; lid design, by Alex Vincent

C. **Beading around the edge adds a delicate and subtle dressing up.**
 Beaded vase, by Kim Campbell

D. **A five-sided base with a fussy-cut handkerchief (mistakenly sewn inside out, then turned) made for a fun shape.** Handkerchief vase, by Linda Johansen

E. **Try embellishing the sides with yarn before stitching them together.**
 Embellished vase, by Libby Ankarberg

F. **Fussy cutting fabrics with motifs adds a definite theme to the vase.**
 Geisha vase, by Linda Johansen

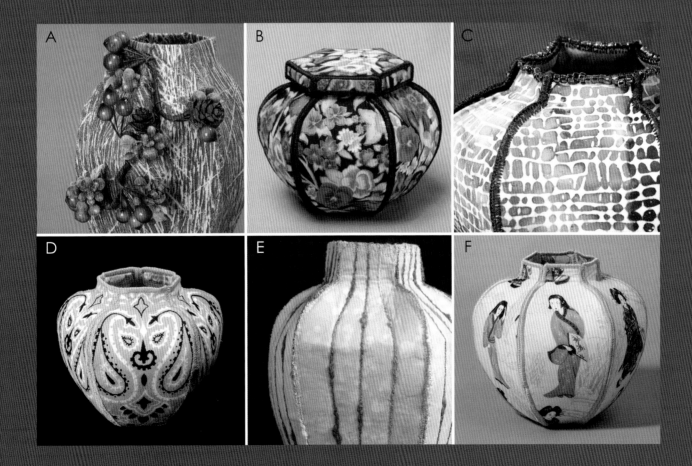

classic vase

Elegant, classy lines. Stylish, graceful fabric. Small or tall. Any way you cut it, this vase is **easy to make.** Put it on the mantel or at the center of the table—it will be a winner.

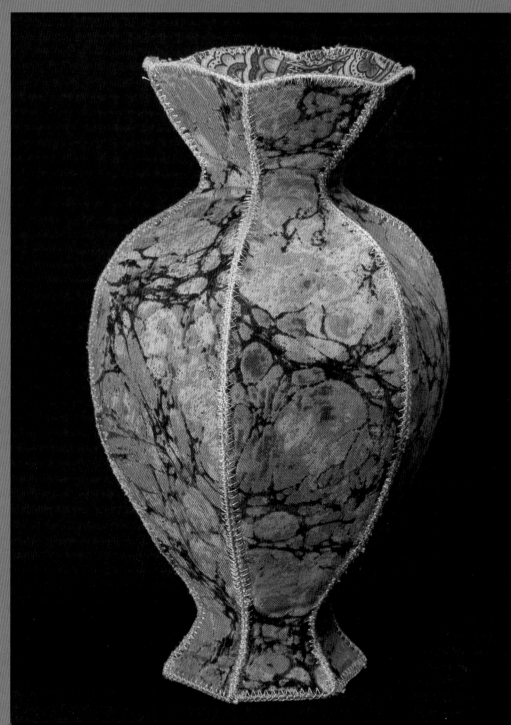

What You'll Need

- [] 2 fat quarters coordinating fabrics
- [] 16½″ × 10″ and 3″ × 3″ stiff interfacing (I recommend fast2fuse for this vase.)
- [] 1 yard fusible web (if not using fast2fuse)
- [] 4 yards decorative cording to match or accent fabric
- [] Thread to match fabrics and cording
- [] Template plastic (optional)
- [] Sturdy balloon
- [] Side and base patterns (page 40)
- [] Basic supplies (pages 6–9)

How-Tos

making a template

1. Trace the side and base patterns (page 40) onto template plastic.

2. Cut out the side template, being careful to keep both edges symmetrical.

3. Cut out the base template.

fun!

Change the shape—bigger curves equal a more voluptuous shape.

fusing

1. Cut 1 piece 16½″ × 10″ and 1 piece 3″ × 3″ from each fabric.

2. Fuse a fabric to one side of the stiff interfacing. (If not using fast2fuse, apply fusible web to the back of the fabric pieces first.)

3. Iron the second fabric onto the other side of the stiff interfacing. Use a rotary cutter and ruler to trim the long edge of the stiff interfacing sandwich.

4. Repeat this for the 3″ base piece.

marking and cutting

1. Place the vase template on one side of the large sandwich piece, and draw around it 6 times for the sides and once on the 3″ square for the base. Draw on the inside fabric or cut just inside the drawn lines so that the lines don't show on the finished vase.

2. Using sharp scissors or a small rotary cutter, cut out the pieces.

easy!

Quilt the vase sides with decorative thread after you mark them and before you cut them out.

fun!

Fuse an extra decorative piece of fabric onto the side(s) before constructing the vase.

stitching the sides

1. Zigzag colored or decorative cording on each side. Start at the top of one side, and sew cording down that side, across the bottom, and then up the next side. Use a 4.0-width, 1.5-length stitch, and backstitch at the start and end. Don't put cording on the top edge or satin stitch yet! (For complete directions on adding the cording, see pages 10-11)

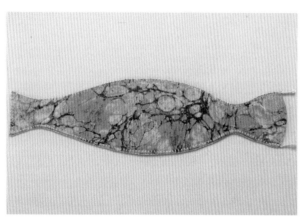

Zigzag decorative cording onto the sides.

2. Zigzag some of the same cording around the base piece.

3. If you want to (or if your cording doesn't match your fabric well), you can satin stitch all the sides after you add the cording.

easy!

If you make this one out of canvas, be sure to do lots of quilting to hold the sides together.

attaching the base

1. Place the bottom of a side piece next to one side of the base piece. Place the outside fabric up on all of the pieces.

2. Zigzag these pieces together using a 1.5-width, 1.5-length stitch. Do some stitches in place at the beginning and end of each piece as you add them.

3. Continue placing the bottom of each side piece next to the base, and zigzag around the base until all six are attached.

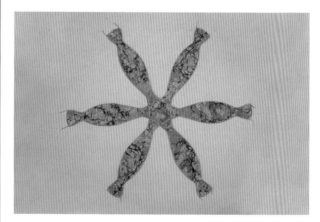

Satin stitch the side pieces to the base.

shaping the vase

1. Fold 2 adjacent sides together with the fabrics that you want inside the vase facing each other.

2. Pin the top edges to make sure they will match.

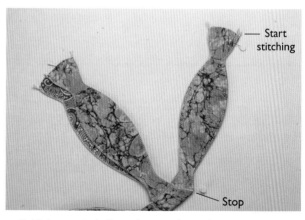

Fold the vase in half, pin the top edge, and zigzag the edge.

3. Sew from the top of the vase down the side to the bottom, using a narrow, short-length zigzag (1.5–2.0 width and 1.5 length). Backstitch at the start, and finish to hold the seams well.

4. Sew two seams while it is flat, then continue matching sides and zigzagging them together. You will need to scrunch the stiff interfacing to match the sides.

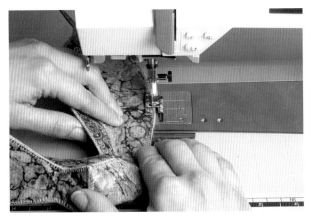

Carefully zigzag up the sides.

finishing the lip

1. Trim the edges even, if necessary, and zigzag cording around the lip (see page 10–11). Stop frequently to "roll" the vase, and don't be afraid to scrunch the vase to get most of it out of the way while you sew around the lip.

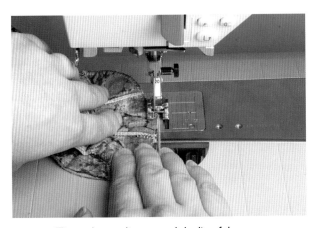

Zigzag the cording around the lip of the vase.

easy!

If a side seam pulls apart a bit on the lip, pull gently and firmly on the cording as you zigzag to pull the edges together. You should restitch big pull-aparts before applying the cording!

2. If you want (or if your cording doesn't match well), satin stitch around the lip after you add the cording.

fun!

Patch fabrics together for a real quilted vase. Iron fusible web onto the fabrics before sewing them together, and carefully iron down the seam allowances so that they don't puff up when ironed to the fast2fuse. (Use 2 layers of fusible web if using Timtex.) Fussy cut the sides if you want them to match exactly.

steaming

1. Blow up a large, sturdy balloon inside the vase.

2. Steam the vase to shape while the balloon is full, and leave in the balloon while the fabric cools. See photo (page 11) for reference.

3. Steam the base, and gently press it on something flat to cool.

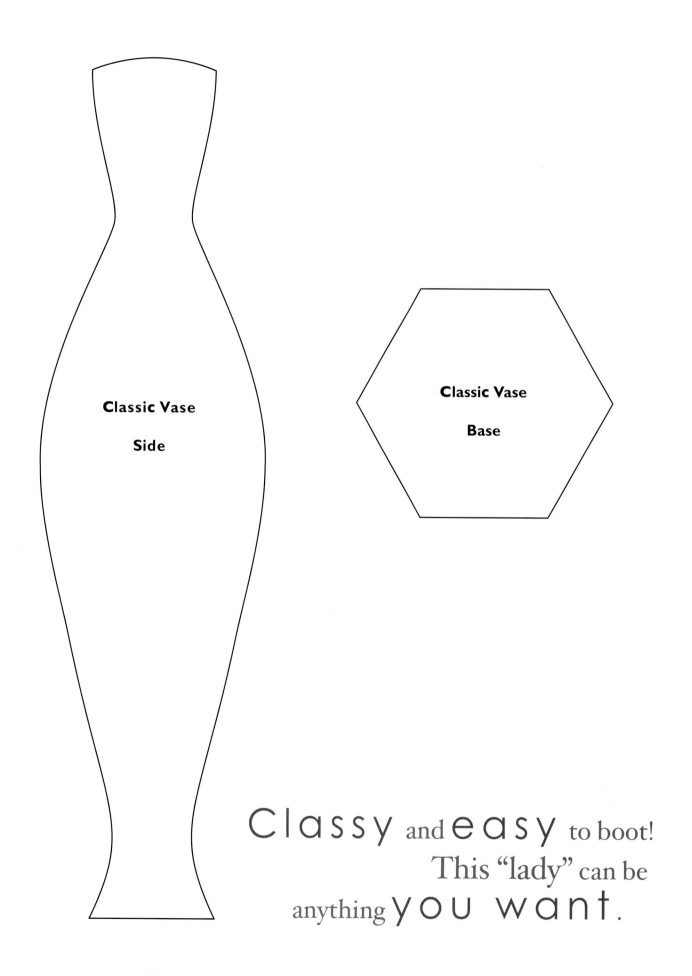

Classic Vase

Side

Classic Vase

Base

Classy and easy to boot!
This "lady" can be
anything you want.

Variations

Play with the curves a bit, and this vase can become voluptuous or emaciated. Just a small change in the shape can make a big difference in the finished appearance.

A. Narrowing the pattern a bit gives this vase a sexy silhouette. Sexy vase, by Linda Johansen

B. Widening the pattern and deepening the curves creates a voluptuous vase! Voluptuous canvas vase, by Linda Johansen

C. Flame fabric takes the focus off the shape and makes a startling statement. Flame vase, by Linda Johansen

D. Lengthening the neck using very modern fabric with canvas interfacing, and then pushing the neck down inside makes a vase with an unusual shape. Modern vase, by Kim Campbell

E. This little Aladdin vase was made with a circle cut out of the base so that a glass could be put inside to hold water for flowers. Aladdin vase, by Kim Campbell

F. Tall, statuesque, and fussy cut, this vase speaks for itself. Statuesque vase, by Sidnee Snell

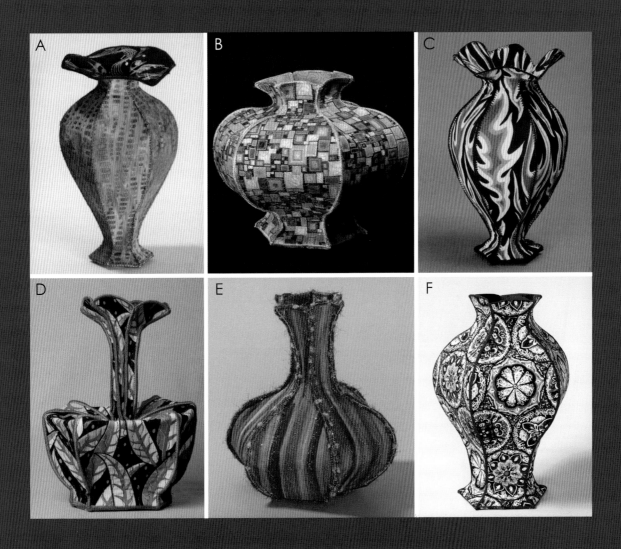

ellipse vase—
fish bowl

There's nothing fishy about this vase, unless you choose fishy fabric. It also looks great done with classy fabric for a simple, elegant vase.

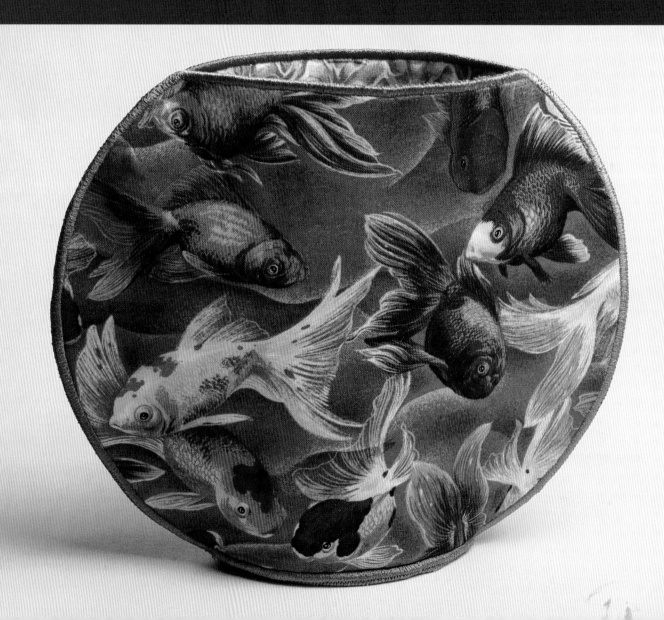

What You'll Need

- ☐ 2 fat quarters coordinating fabrics
- ☐ ½ yard stiff interfacing
- ☐ 1 yard fusible web (if not using fast2fuse)
- ☐ Thread to match or contrast with fabrics
- ☐ 1½ yards (for small bowl) or 2 yards (for large bowl) cording
- ☐ Template plastic (optional)
- ☐ Side and base patterns for small or large ellipse vase (pages 45–46)
- ☐ Basic supplies (pages 6–9)

How-Tos

cutting and fusing

1. Cut 2 pieces of stiff interfacing 6¼″ × 7½″ and 1 piece 2″ × 3½″ (small) or 2 pieces 8″ × 9½″ and 1 piece 3″ × 4½″ (large).

2. Cut 2 pieces each of inside and outside fabric 6¼″ × 7½″ and 1 of each 2″ × 3½″ (small) or cut 2 of each 8″ × 9½″ and 1 of each 3″ × 4½″ (large). (Be aware of any directional designs on your fabric. If you are using fish, they swim better right side up!)

3. Fuse the inside fabric pieces to one side of each stiff interfacing piece. (If not using fast2fuse, apply fusible web to the back of the fabric first.)

4. Fuse the outside fabric pieces to the other side of the stiff interfacing pieces.

5. Trace the side and base patterns (page 45 or 46) onto template plastic and cut out.

6. On the inside fabric, trace 2 sides and one base on the fabric sandwich pieces, and cut them out. Be aware of any directional designs on your fabric.

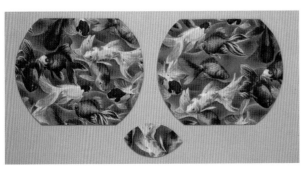

Pieces needed for the ellipse vase

stitching the pieces

1. Zigzag the cording around each piece, using a 4.0-width, 1.5-length stitch. (For complete directions on adding cording, see pages 10–11.)

2. Satin stitch around each piece individually.

shaping the vase

1. Set your machine for a narrow zigzag stitch (1.5 width and 1.5 length) to sew the sides to the base.

2. Align the corner edge of the elliptical base with the bottom edge of a vase side. Keep the base on top while sewing, and make sure the edges match as you go. The right stitch of the zigzag should go out over the edge of the pieces. You want to just catch the edge of the satin stitching on both pieces.

Align the base with the side.

3. Start by sewing several stitches in place, or backstitching. Pull the base to meet the edge of the

side as you sew. Backstitch at the end. The side will curl up and begin to shape as it passes under the presser foot. If the ends don't quite match, it's okay; when you sew the sides together, you can cover it.

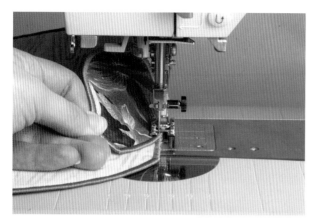

The side will curl up as you sew. That is good!

4. Sew the other side on in the same way. You will need to bend or fold the stiff interfacing to fit the vase under the presser foot. Begin sewing at the opposite end of the base that you did with the first side.

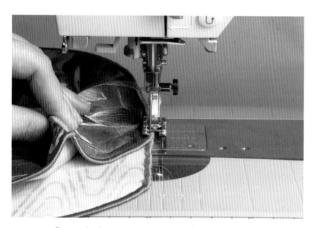

Scrunch the vase as you sew the second side.

easy!

Before sewing your vase, use scraps to cut an ellipse shape, and practice adding sides to it if you want to see what will happen.

5. Fold the 2 halves together, and pin the top edge on one side.

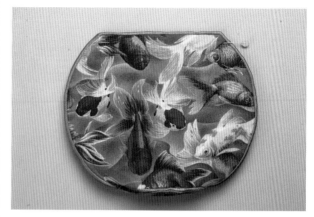

Pin the sides, as needed, for accuracy.

6. Begin sewing down the side from the top. You will need to fold the base in half to do this. Remember to backstitch at the beginning and end of the seam.

finishing

1. Steam iron the base first, and hold it on something flat until it's cool and holds the shape you want.

2. Steam iron the sides as necessary. I usually like to steam the top opening a bit rounder than it wants to be without shaping. Just hold it in the shape you want it, or place something round in it while it cools.

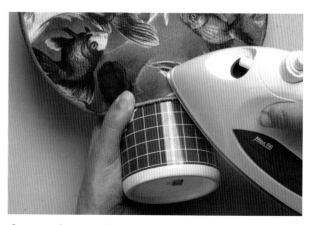

Save your fingers and use a glass, a jar, or a ball of string to help steam the lip to a round shape.

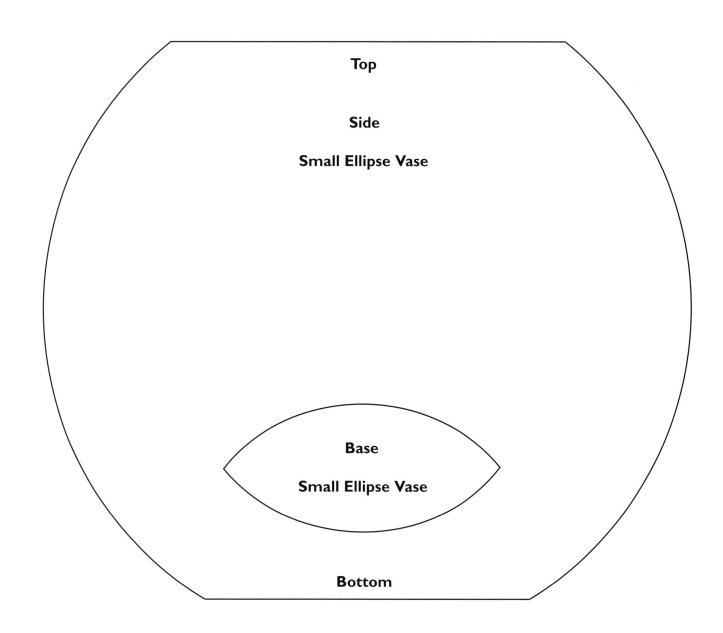

Top

Side

Small Ellipse Vase

Base

Small Ellipse Vase

Bottom

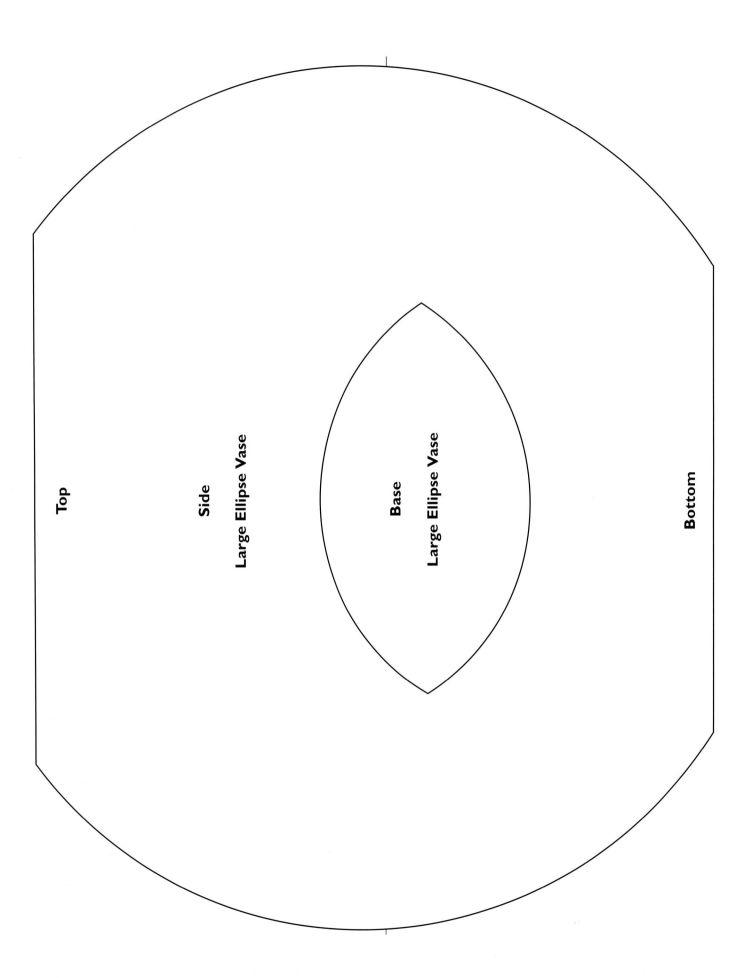

Top

Side
Large Ellipse Vase

Base
Large Ellipse Vase

Bottom

fast, fun & easy FABRIC VASES

Imagine a bowl of
fish that you never have to feed.
Now when your kids ask for fish, you can do it
without the worry or the water.

Variations

Try your fish tropical, realistic, or cute. Everyone will comment on this fishbowl, even if you don't put fish in it! You don't even have to keep it elliptical.

A. Two rectangles and a freehand-cut, sort-of-elliptical base were embellished with stitching before assembly for this sensuously shaped canvas art vase. Freehand-cut vase, by Kim Campbell

B. By adding width to the base and two extra sides, you can have an even more realistic fish bowl. Dolphin vase, by Linda Johansen

C. A small triangle base and three sides of thread-embellished sandwich were combined for this cute jungle vase. Jungle vase, by Kim Campbell

D. It doesn't have to be a fish bowl! Hand-dyed fabric gives this vase a very elegant, classic look. Elegant vase, by Linda Johansen

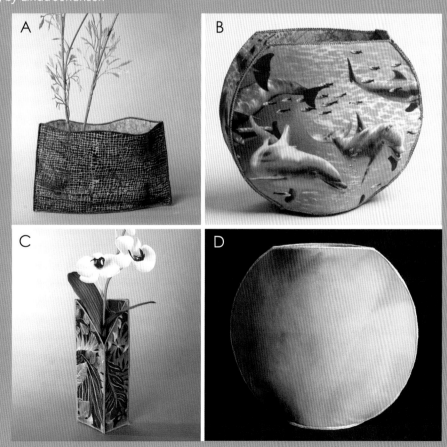

Resources

C&T Publishing, Inc.
Concord, CA 94520
800-284-1114
www.ctpub.com
fast2fuse Double-Sided Fusible Stiff Interfacing 28″ wide (bolts hold 10 or 40 yards), available in regular and heavyweight. Also available at your local quilt store.

Clearview Triangle rotary ruler
Snohomish, WA 98296-4802
888-901-4151
Or ask for it at your local quilt store.

Freudenberg/Pellon
800-331-6509
www.ShopPellon.com
Wonder-Under: Pellon transfer web #805
Available at most quilt and sewing stores.

Prym-Dritz Corporation
Spartanburg, SC 29304
800-255-7796
www.dritz.com
Omnigrid products

Oklahoma Embroidery Supply & Design (OESD)
Oklahoma City, OK 7331
405-359-2741
www.embroideryonline.com
Isacord Thread
Large spools carry 1,000 meters. Small spools, which carry 200 meters, are sold as Mettler Polysheen. Or ask your local quilt store to carry it.

Timber Lane Press (Timtex is made exclusively for this company; will take wholesale orders or recommend retail outlets)
Hayden, ID 83835
800-752-3353
email: qltblox@earthlink.net
Timtex: 22″-wide yardage (bolts hold 10 yards) Also available through major quilting supply distributors and your local quilt store.

Trimtex Company, Inc.
Williamsport, PA 17701
www.trimtex.com
Rattail cording

Additional Quilting Supplies

A Common Thread
16925 SW 65th
Lake Oswego, OR 97035
877-915-6789 (toll free)
email: actbernina@aol.com
www.acommonthreadfabrics.com

Cotton Patch Mail Order
3405 Hall Lane, Dept. CTB
Lafayette, CA 94549
800-835-4418
email: quiltusa@yahoo.com
www.quiltusa.com

Fabrics
Most of the samples in this book were made with fabric from the following companies. Ask for them at your local quilt store!

Classic Cottons
www.classiccottons.com

Johansen Dyeworks— Hand-Dyed Fabrics
www.lindajohansen.com

Robert Kaufman Fabrics
www.robertkaufman.com

RJR Fabrics
www.rjrfabrics.com

Timeless Treasures
www.ttfabrics.com

About the Author and Artists

Photo: John Halley

Linda Johansen is the author of *Fast, Fun & Easy Fabric Bowls*; *Fast, Fun & Easy Fabric Boxes*; *Fast, Fun & Easy Irresist-A-Bowls*; and now *Fast, Fun & Easy Fabric Vases*. She lives in Corvallis, Oregon, with her husband and two dogs.

For all four books, she has had the help of a very special and creative group of women who deserve a lot of credit for everything from the details of editing and making how-to samples to the fun of working out the design ideas and construction. You've seen their names and creations; now Linda would like you to meet them.

Libby Ankarberg began quilting nineteen years ago when she left civil engineering to raise a family, which now includes three teenagers and two dogs. Never one to do things by the book, both her fabric art and glass fusing provide an outlet for her love of color and texture.

Kim Campbell feels that the older she gets, the more certain she is that everyone needs a playgroup. She values the opportunity to get together and play and create—to work with others in a collaborative effort, exploring the challenges, enjoyment, and satisfaction of making art. And she'll do anything to get out of satin stitching!

Sidnee Snell goes straight for her sewing machine (not a blankie or teddy bear or even chocolate) when looking for comfort. She has been sewing since she was a kid, and the sound of a sewing machine is familiar. When not quilting, she enjoys tap dancing and singing off-key in the shower. See more of her work at www.sidneesnell.com.

Alex Vincent, a former molecular biologist (studying octopus genes), began her quilting with a group of women making raffle quilts for her children's school. Enjoyment of the company of her family and friends, and delight in the beauty of the natural world, influences her textile work.

Libby Ankarberg

Kim Campbell

Sidnee Snell

Alex Vincent